D0128139

LONELY PLANET'S BEST EVER
PHOTOGRAPHY
Tips

lonely planet

RICHARD I'ANSON

MELBOURNE | LONDON | OAKLAND

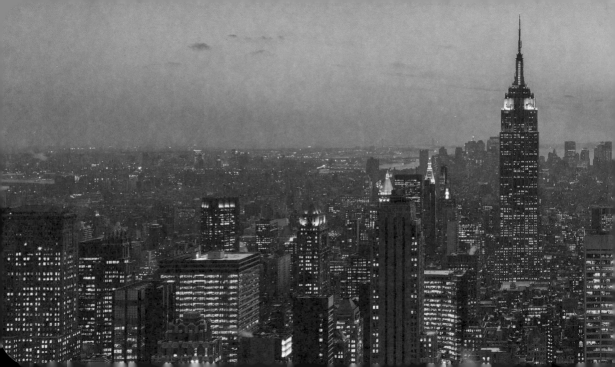

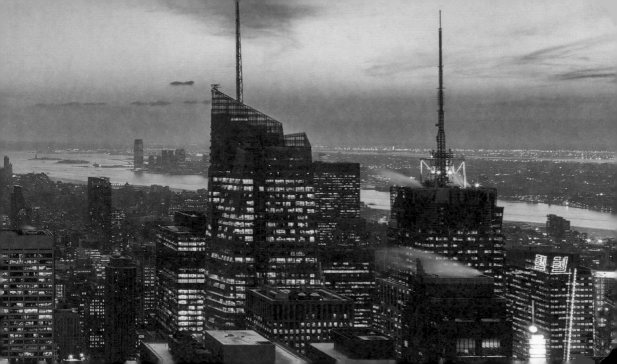

CONTENTS

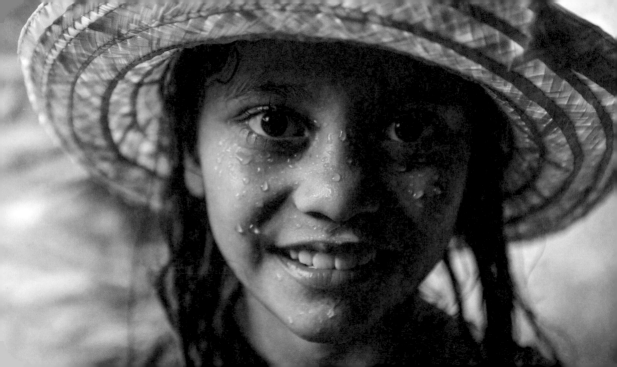

INTRODUCTION

GREAT PICTURES ARE the result of matching an interesting subject with the best light, a pleasing placement of the elements and exposing the sensor to just the right amount of light to translate the way you see the scene onto the camera's sensor. It is how the photographer handles this combination of technical and creative skills at a particular moment in time that produces unique images and allows individuality to shine through.

THESE 55 TIPS offer a concise insight into the thinking, behaviours and the creative and technical skills required to produce vibrant and dynamic images across the wide range of subjects and situations you're likely to encounter everywhere, from your own backyard to the other side of the world. Put them into practice and you'll increase the percentage of good photographs you take and lift your photography to the next level of creativity and consistency.

– THE –

10

GOLDEN RULES

TAKE CONTROL OF THE PICTURE-TAKING PROCESS

Take control of the picture-taking process by learning the technical stuff so you can take your camera off the fully Automatic or Program settings. And get to know your gear so that the mechanics of taking a photograph become second nature.

Automatic features are brilliant if you know what they are doing and what impact they are having on the image – then you can decide if that is really how you want your photo to look. Particularly, understand the exposure triangle – ISO, shutter speed and aperture – so that the multiple options you have for setting a correct exposure become instinctive. This will allow you to use the settings as creative tools that control the mood, quality and feel of the photograph, rather than just as a technical necessity.

As for gear, the minimum aim should be to know how to change the ISO, shutter speed and aperture settings, turn the flash on and off, change lenses and filters and get your tripod up, camera mounted and shutter-release cable attached; all as quickly as possible.

With this combination of technical knowledge and practical skills you'll then be able to concentrate on and enjoy the creative side of photography by seeking out interesting subjects and great light. You'll also have a much better chance of capturing more images at exactly the right time, especially those fleeting moments and expressions that make unique photographs.

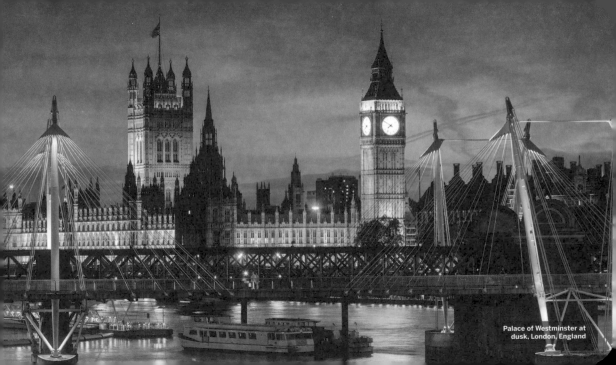
Palace of Westminster at dusk, London, England

LEARN TO SEE THE TRANSFORMATIVE POWER OF LIGHT

The ability of light to transform a subject or scene from the ordinary to the extraordinary is one of the most powerful tools at the photographer's disposal. To be able to 'see' light and to understand how it translates onto the sensor and how it impacts on your compositions is the final building block in creating striking images.

There's light and there's the 'right light'. The keys to the right light are its colour, quality and direction. As your eye settles on a potential subject, note where the light is falling and select a viewpoint from where the light enhances your subject. There is an optimal time of day to photograph everything, so be prepared to wait or return at another time if you can't find a viewpoint that works. However, most subjects are enhanced by the warm light created by the low angle of the sun in the one to two hours after sunrise and before sunset. At these times shadows are long and textures and shapes are accentuated. If you're serious about creating good pictures, this is the time to be out and about shooting. Given all other things are equal, it's the light in which a photographer shoots that sets images apart.

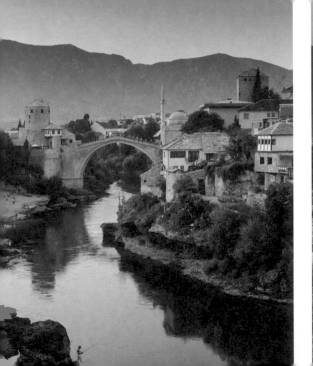
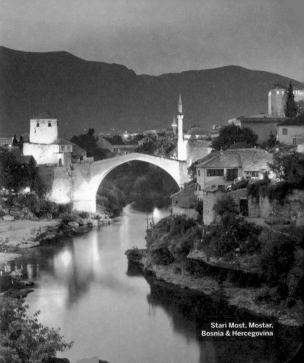

Stari Most, Mostar,
Bosnia & Hercegovina

RULE

03 PRACTISE, PRACTISE, PRACTISE

Once you've got the technical stuff sorted, can work efficiently with your gear and can see the light; practise. You can photograph most of the subjects you'll encounter while travelling in any town or city in the world, including your own.

Planning and executing a shoot of your own city is a great way to practise your research skills, test your camera equipment, perfect your technique, develop your eye and get a feel for changing light. Buy a guidebook, check out the postcards and souvenir books, and draw up a shot list. Treat the exercise exactly as you would if you were away from home. You'll quickly get an insight into just how much walking you can expect to do, how many locations and subjects you can expect to photograph in a day, and how manageable your equipment is.

You can then use this knowledge to plan your trips away from home a little more accurately to meet your goals. As a bonus, you'll be rewarded with a fresh insight into your home town. You're sure to see it in a different light and to discover subjects and places you didn't know about.

Centre Place,
Melbourne, Australia

04 RESEARCH & PLAN

Research and planning go a long way to getting you to the right place at the right time more often than not. The more time you have, the more opportunities you give yourself to photograph subjects in the best light. Photographers demand more time in a place than the average camera-toting tourist – sometimes just a few extra minutes can make all the difference. The sun may come out or go in, the right person may stop and stand in just the right place, the rubbish-collection truck parked in front of the city's most beautiful building may move on, the people buying fruit may hand over their money. If you have days rather than minutes, you can look for new angles and viewpoints of well-known subjects, visit places at different times of the day, shoot in a variety of great light, and get better coverage.

Check out the dates of special events such as festivals, public holidays and weekly markets. The spectacle, colour and crowds that are the hallmarks of these special days provide so many great photo opportunities that it's worth planning your trip around them.

For the most productive and enjoyable time, ensure you have an understanding of the size and layout of the city, or general area in the case of nature-based destinations, and the locations of the key sights and activities. Stay in the most central location you can (and book a room with a view). Accommodation may be cheaper on the edge of town but you'll have to spend more money on taxis, walk further, get up earlier and carry around extra bits of gear (such as a tripod) when you don't need them.

Beijing 19092 km
MEXICO 7598 km
Taj Mahal 15511 km
La Paz 2735 km
LA MECA 11874 km
Londres 11011 Km

BAHIA 2964 Kmts
DOHA 13.030 Kmts
Santa Cruz 2002 Km
Nana ♥ "8" Kmts

Punta del Este, Uruguay

05 DEVELOP A PICTURE-TAKING ROUTINE

Potential images abound – they will come and go in front of your eyes in a matter of seconds and are easily missed. A good routine plays a big part in helping you find great subjects and to react quickly enough to capture them.

- Get out and walk. You'll add first-hand knowledge to your research, and the map will make more sense.

- Ensure you've got enough memory and battery power for the day, and a pad and pen for taking notes.

- Get up early. The light is often at its best, the activity in towns and markets is at its most intense and interesting. You'll be rewarded with experiences and images that most people miss.

- Have your camera around your neck, switched on and with the lens cap off. And fit the lens you're most likely to need.

- Be aware of existing light conditions and have your camera set accordingly.

- Constantly check the ISO setting is appropriate, especially if you're in and out of low-light interiors.

- Know where you're going to be shooting first thing in the morning and in the last couple of hours of daylight.

- If a subject appeals, never assume that you'll see it again later. Shoot first, and reshoot later if a second or better opportunity presents.

Grand Canal, Venice, Italy

BE PATIENT & COMMIT TO THE IMAGE

So much time creating good pictures is spent not actually taking pictures but incessantly looking, either on the move or standing around; watching, waiting. Very few really good photographs are the result of random, machine-gun-fire technique or accidently being in the right place at the right time. Plus, if you're out and about you create the opportunity to come across fleeting moments. You will not get those 'lucky' pictures from your hotel room or bar stool.

When you do find a great location and the light is just right – but an element beyond your control is needed to make the picture, such as a child in a red jacket running into frame – you'll have to balance the competing desires of trying to see everything and patiently waiting for the perfect moment to create interesting pictures. If possible wait; be patient; commit to the image. Whether it's a matter of seconds for an action to occur, a couple of hours for the weather to change or revisiting a location at the best time of day, the quality of your images will improve dramatically. Commitment to the image is a key professional trait; it keeps photographers out there way beyond the time needed to simply visit a place.

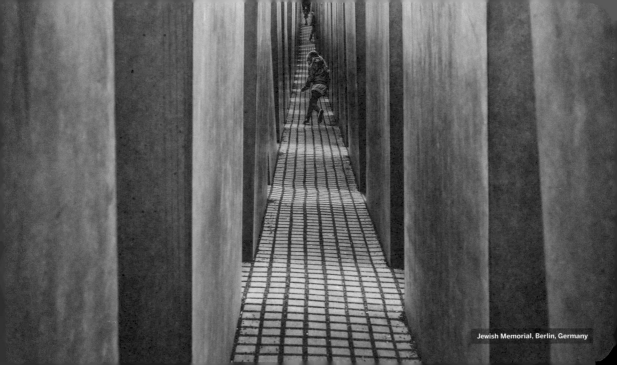
Jewish Memorial, Berlin, Germany

RULE 07 PAY FOR PHOTOS ONLY WHEN IT'S APPROPRIATE

In popular destinations you could be asked for money in return for taking a photo. This may be considered a fair and reasonable exchange by some or a tiresome annoyance by others, or it may simply discourage you from photographing people. Ultimately you'll have to come up with a personal response. Certainly, don't hand out money (or sweets, pens or anything else for that matter) if it's not requested, but if it is be prepared to pay or walk away. From a photographer's point of view it really comes down to how important or unique the potential image is. If you do decide to pay:

- Agree on the price beforehand to avoid problems afterwards and make sure you're working in local prices, not yours at home.

- Bargain.

- Always have coins and small denomination notes with you in an easily accessible pocket (a different pocket from where you carry the rest of your money). This means you won't have to pull out great wads of money, confirming not only that you are relatively rich (as if the camera hadn't already done that) but more importantly where you actually keep your money, making it much easier for someone who may want to relieve you of it.

- Don't give money to children.

- Always donate to those who make their living from donations such as beggars, monks, Sadhus and buskers.

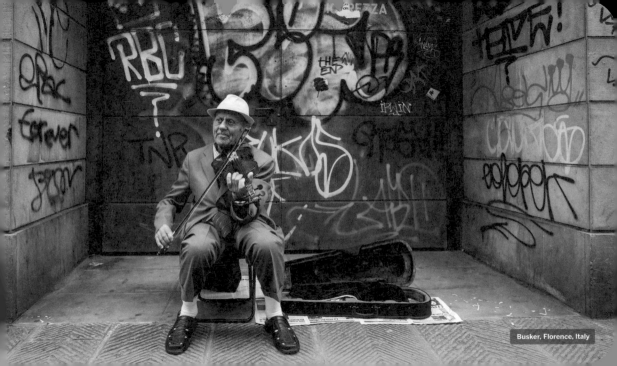

Busker, Florence, Italy

08 SHOOT RAW FILES

If you want to get the very best results from your digital camera, capture your images using the raw file format, an option available on advanced compacts and DSLR cameras. Often described as a digital negative, it's the format preferred by professional photographers.

Raw files are not processed by the camera's software, which compresses the data and makes adjustments that are permanently embedded in the image file. Instead, raw files are compressed using a lossless process, so they retain all the information originally captured, but are saved to the memory card quickly. Adjustments such as white balance, exposure, contrast, saturation and sharpness are made by the photographer after the image has been downloaded to a computer.

Creative decisions can then be tailored to each image using the much greater functionality of image-editing software.

Alps at sunset, Gornegrat, Switzerland

BECOME PROFICIENT WITH
IMAGE-EDITING SOFTWARE

Shooting raw files requires a considerable amount of post-capture computer time and more than a basic understanding of image-editing software. Raw files must be processed or converted before they can be opened in photo-editing programs. Cameras with raw file capture are sold with proprietary software for that purpose. Alternatively, you can use a third-party specialist raw-conversion program or most typically one that is included in your image-editing software.

As with image capture you can use automated features to make the process quicker, but to obtain the absolute best results and produce digital files and prints that maximise the capabilities of your camera take the time to learn how to use the powerful tools in your software.

Being proficient with image-editing software is a vital skill for the photographer. Your investment in time, software and computer equipment will be rewarded with the ability to bring your images to life and to have total control over how they look.

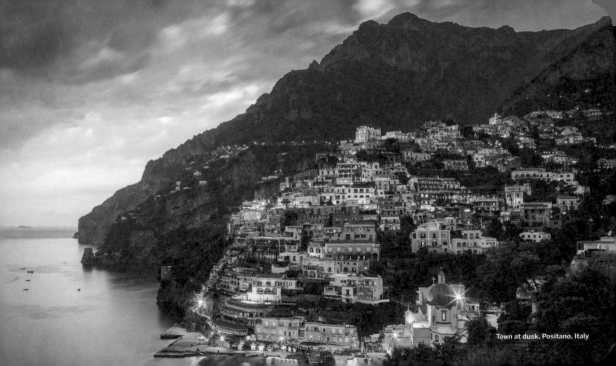

Town at dusk. Positano, Italy

CRITIQUE YOUR PHOTOS OBJECTIVELY

With more pictures being taken and seen than ever before (that's more pictures, not better pictures!), it's important to take some time to critique your own photos in an objective way. This is not easy. We're all emotionally attached to images we take and often enraptured by our own brilliance. Great – but if you want your pictures to stand out, a disciplined assessment of your pictures will give them the best chance of catching people's attention and being appreciated.

The assessment and selection process is an excellent time for reflection and self-teaching. Your best pictures and worst failures will stand out clearly. Study them to see what you did wrong and what you did right. Before you discard an image file, check the EXIF data and see if you can learn anything about why the image didn't work out as you'd expected. Look for patterns. Are all your best pictures taken on a tripod? Are all the out-of-focus frames taken with the zoom at its maximum focal length? Next time you can eliminate the causes of your failures and concentrate on the things that worked. Your percentage of acceptable pictures will start to rise. It's better still if you can complement your own assessment with the views of someone you respect and trust to give honest, constructive feedback. Note that this will very rarely be your family and friends. Self-critiquing is an important and never-ending process in the life of a photographer.

Cathedral, Palermo, Italy

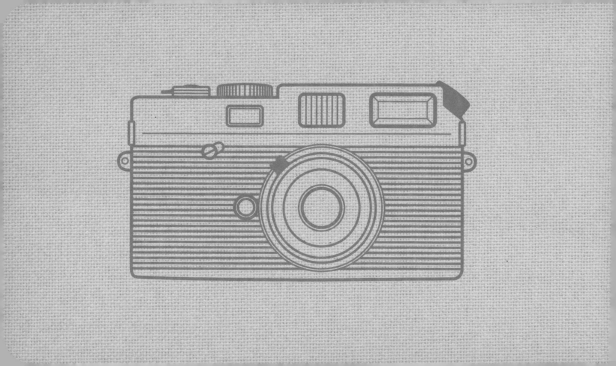

- THE -

45

BEST TIPS

CHOOSE THE CORRECT CAMERA
MATCH YOUR GEAR TO THE KINDS OF SHOTS YOU WANT TO TAKE AND YOUR LEVEL OF INTEREST

Choice of equipment is important; it's the first building block in a series of creative decisions that will lead to you capturing images that reflect your personal photographic vision. You can expect to be out and about for hours at a time...all the while watching and waiting for that great shot, so unless you have very specific aims that demand a truckload of specialist equipment, keep your gear to a minimum. The three options to consider are:

Compact digital cameras (digicams or point-and-shoot) Ideal for taking photos with a minimum of fuss – perfect if you want to travel light.

Compact System Cameras (CSC) or Mirrorless Interchangeable Lens Cameras (MILC) These cameras fill the gap between compact cameras and digital single lens reflex (DSLR) cameras by combining the best features of both, namely APS-C sensors (found in most DSLRs) and interchangeable lens systems, to produce excellent image quality in compact design styles. Consider a CSC if you want the flexibility to choose different lenses, but are put off by the size of DSLR systems.

Digital Single Lens Reflex cameras If you're serious about photography and aiming for success across the widest range of subjects in all situations, you can't go past a DSLR with a couple of zoom lenses such as a 24–105mm and a 70–200mm.

Festival of Yemanjá,
Montevideo, Uruguay

ACCESSORISE!

A FLASH, TRIPOD, SHUTTER-RELEASE CABLE, FILTERS AND LENS HOODS ARE ALL USEFUL ADDITIONS

These items will enhance your experience:

⊙ A tripod helps achieve images with the finest detail. minimises noise in low light indoors or out, maximises depth of field and enables slow shutter speeds for creative effects.

⊙ A shutter-release cable, or remote wireless switch, is needed if you mount your camera on a tripod and shoot at slow speeds so you can fire the shutter without touching the camera. Compact cameras do not generally accept shutter-release cables, but some advanced compact cameras have wireless or infrared accessories.

⊙ A flash light (if it's not built in to your camera) is handy when it's inconvenient,

impractical, prohibited or simply too dark (even for quality sensors) to set up a tripod.

⊙ An ultra violet (UV) or skylight filter on every lens will protect lenses from dirt, dust, water and fingerprints.

⊙ A polariser filter eliminates unwanted reflections by cutting down glare from reflective surfaces. They intensify colours and increase contrast.

⊙ Lens hoods fitted to every lens prevent stray light entering the lens, which can cause flare, reduce sharpness and affect exposure settings. They will also protect the lenses.

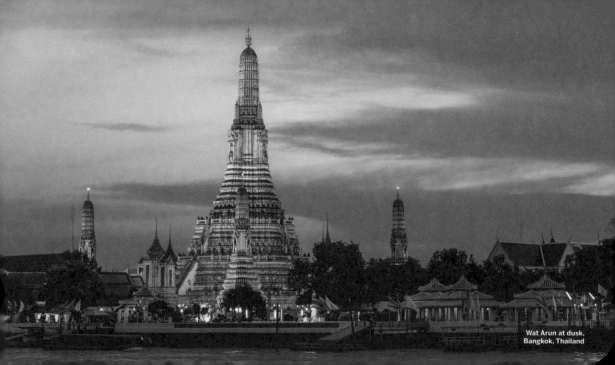

Wat Arun at dusk,
Bangkok, Thailand

USE THE QUALITY CONTROL SETTINGS
CHOOSE THE HIGHEST-QUALITY SETTING FOR THE GREATEST RANGE OF POST-CAPTURE OPTIONS

Selecting the correct image-quality setting at the point of capture is critical to what you can do with the image file post-capture and is particularly important in relation to printing options. Additionally, your choice will determine how many photographs can be stored on your memory card.

- Small or low-resolution files allow the maximum number of images to be stored and are ideal for emailing and web use. However, they are unsuitable for printing.

- Fewer high-resolution images or large files can be stored on a memory card, but these allow the largest photo-quality prints to be made. The maximum size of the print is primarily determined by the number of pixels captured by the camera. For example, bigger prints can generally be made from the biggest file size on a 15MP camera than from the biggest file size on a 10MP camera.

- Given you probably won't know exactly how the images are to be used, it is highly recommended that you shoot at the highest-quality setting your camera allows. Large files can always be made smaller for email or web use through image-editing software, but enlarging small files generally creates unsatisfactory results.

Sunrise over Mary River floodplain,
Bamurru Plains, Australia

SELECT A SUITABLE FILE FORMAT
SHOOT RAW FOR THE BEST QUALITY OR JPEG FOR CONVENIENCE

If your camera gives you the choice of shooting in JPEG or raw, consider how you intend to use your photos.

Shoot JPEG if:

- You don't want to spend time enhancing your images in image-editing software.
- The pictures are for personal use in photo albums and to share on websites.
- You want to get as many photos on the memory card as possible.

Shoot raw if:

- You want the best possible results from your camera.
- You're willing to spend considerable time working with your files on the computer.

- You have any ambition to exhibit, sell, publish or place your images with a photo library.
- You intend to print images larger than 20.3cm x 25.4cm (8in x 10in).

Some cameras offer the option to capture raw and JPEG files simultaneously. As camera processing software becomes faster and memory cards cheaper, this option is becoming quite viable. It allows you to organise and edit your images quickly and easily in any image-editing software using the JPEG files, as well as keeping the option to process in raw your best images or those that could use some serious post-capture help to look their best.

Carnaval Parade,
Rio de Janerio, Brazil

ADJUST YOUR EXPOSURE

CONTROLLING THE AMOUNT OF LIGHT THAT REACHES YOUR CAMERA'S SENSOR IS A CORNERSTONE OF CREATIVE PHOTOGRAPHY

Correct exposure means the sensor is exposed to just the right amount of light to record the intensity of colour and details in the scene that attracted you to take the photo in the first place. Too much light and the image is overexposed and will appear too light. Not enough light and you have underexposure and the image is too dark. A good exposure is achieved through a combination of the sensor's ISO rating, the aperture setting and shutter speed:

ISO Image sensors are light sensitive and the ISO rating is the foundation on which the variable settings of shutter speed and aperture are based. As the ISO setting is increased, the sensor becomes more sensitive to light.

Shutter speed The amount of time that the camera's shutter remains open to allow light onto the sensor. Shutter speeds are measured in seconds and fractions of seconds.

Aperture The lens opening that lets light into the camera body. The aperture is variable in size and is measured in f-stops.

These elements are known as the exposure triangle and an understanding of how they interact with each other, and the ability to quickly assess the best combination required for a specific result, is fundamental to creative photography. By varying these three elements of the exposure triangle the same scene can be portrayed quite differently.

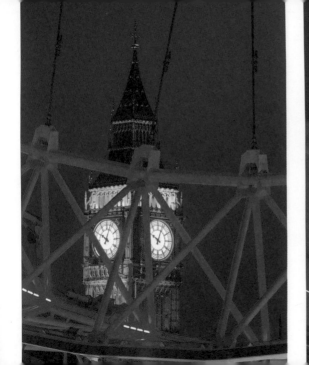
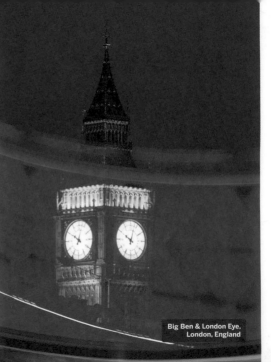

Big Ben & London Eye,
London, England

CAPTURE THE WIDEST TONAL RANGE
BRACKET AND USE HDR PROCESSING IN DIFFICULT LIGHTING SITUATIONS

Bracketing is a technique to ensure that the best possible exposure is achieved when shooting high contrast scenes where the composition includes bright highlights and deep shadows. A standard bracket requires three frames of the same scene:

- The first is at the recommended exposure, say 1/125 at f11.
- The second, generally at half a stop over (1/125 at f9.5).
- The third at half a stop under (1/125 at f13).

Many cameras have an auto-bracket setting that allows you to select a three-exposure bracket at third-, half- or one-stop increments. The camera captures all three images in one burst. With raw files you can also use High Dynamic Range (HDR) processing to produce images with the widest tonal range. The scene is captured on three bracketed frames starting with the camera's recommended setting (top left) followed by -2 (middle) and +2 stops (bottom). The files are then combined in image-editing software to produce a single file displaying detail from the darkest to the brightest shades (opposite right). You'll need to:

- Mount the camera on a tripod.
- Use the Aperture Priority exposure mode so the depth of field doesn't vary.
- Avoid moving subjects.

Software editing tools are also capable of creating an HDR image from a single raw file.

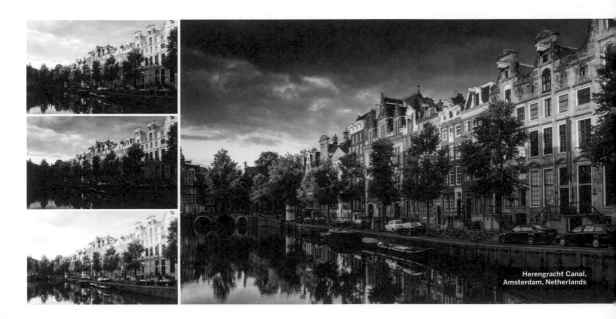

Herengracht Canal,
Amsterdam, Netherlands

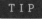

CHECK THE EXPOSURE IS CORRECT
LEARN TO READ A HISTOGRAM

Histograms are a graphic representation of the distribution of pixels, or tonal range, in the image, showing their relative weighting in the shadow, midtone and highlight areas. The histogram is viewed on the LCD screen after the picture has been taken and is a powerful tool for determining correct exposure when capturing JPEG files. Understanding the readout allows immediate assessment of the exposure and the opportunity to adjust settings and reshoot if necessary. Consulting the histogram is also useful while shooting in very bright conditions when the image on the LCD screen is difficult to see.

◉ For general photography the aim is to see pixels spread across the horizontal axis, with most of them in the centre of the graph, indicating that detail has been recorded in the shadows, midtones and highlights.

◉ If the pixels are bunched too far to the right side of the histogram, the image will be overexposed and the image too light.

◉ If they are bunched too far to the left the image will be underexposed and the picture too dark.

◉ There is not one ideal histogram. The tonal range can vary significantly from image to image, influenced not only by the exposure settings but also by the subject matter.

The histogram has limited use when shooting raw as it is based on the camera-processed JPEG file rather than the raw camera data.

SHADOWS MIDTONES HIGHLIGHTS

Agile wallabies, Bamurru Plains, Australia
Inset: the photograph's histogram

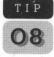

STAY WITHIN RANGE OF YOUR FLASH
... OR SUFFER SHADOWY PICTURES

Most cameras have built-in flash units, otherwise a separate flash can be mounted via the camera's hot-shoe or off the camera on a flash bracket with a flash lead. Pictures taken with flash from built-in or hot-shoe-mounted units are usually unexceptional. The direct, frontal light is harsh and rarely flattering. It creates hard shadows on surfaces behind the subject and backgrounds are often too dark. Improve your flash photos by:

- Making sure your subject is within the power range of your unit, typically between 1m and 5m from the camera.

- Selecting a higher ISO sensitivity setting to extend the effective range of your flash or to work with smaller f-stops for greater depth of field.

- Selecting one of the flash modes, such as Fill Flash or Night Scene to alter shutter speed and aperture settings and balance the flash light with the ambient light.

Cameras with hot-shoes can achieve better pictures using a flash with a tilt head (mounted on or off the camera) and using bounce and fill-flash techniques and by:

- Aiming the flash at the ceiling, wall or flash reflector, which bounces the light back at the subject. The light is indirect and soft and shadows are minimized.

- Using the flash as a secondary source of light to complement the main light source to add light to shadow areas containing detail that would otherwise be rendered too dark.

Spectators at Mardi Gras Parade,
Sydney, Australia

REDUCE RED-EYE

MINIMISE UNATTRACTIVE RED EYES IN PEOPLE PICTURES WITH YOUR CAMERA'S SETTING

If you use direct, on-camera flash when photographing people your pictures may suffer from the dreaded red-eye, which can make even the most innocent-looking person appear quite demonic. The flash is in line with the lens and the light reflects off the blood vessels of the retina straight back onto the sensor. To try to minimise this problem many cameras have a Red-Eye Reduction feature, which triggers a short burst of pre-flashes just before the shutter opens. This causes the pupil to close down. It's a sophisticated way of increasing the light in the room.

Alternatively, red-eye can be minimised or avoided with the following techniques:

◉ Ask your subject not to look directly into the lens.

◉ Increase the light in the room, which causes the pupil to close down.

◉ Bounce the flash off a reflective surface.

◉ Move the flash away from the camera lens.

◉ Use the red-eye correction or removal tool found in most image-editing software.

Cultural performance, Luxor, Egypt

USE YOUR PHONE LIKE A CAMERA

... AND YOU MIGHT BE PLEASANTLY SURPRISED BY WHAT CAN BE ACHIEVED

Taking photos with a camera phone is no different from using any other type of camera. Apply the same basic photography skills as you do when you're using a compact or DSLR camera and follow these suggestions:

- Set the camera phone's resolution to the highest setting.
- Keep the lens clean.
- Shoot in the brightest possible light and avoid low light.
- If you have a flash, use it indoors and outdoors in low light and when your subject is backlit, but remember its range will be around 1m.
- Use the volume buttons to take the photo rather than the screen button, which will help keep the camera steady.
- Fill the frame by moving closer or pinching on-screen to zoom in.
- Keep the phone cool. As the sensor heats up the noise increases, making for inferior-quality photos.
- Transfer the images to a computer and edit them using image-editing software in exactly the same way as your camera photos. You'll be amazed at how good some of the pictures can look.

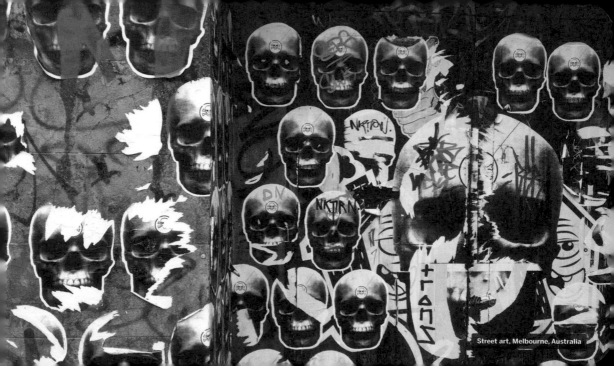
Street art, Melbourne, Australia

PREVENT BLUR

YOUR SUBJECT MAY HAVE MOVED — BUT BLURRED PICTURES ARE MOST COMMONLY DUE TO CAMERA SHAKE

A practical consideration when selecting shutter speeds is to ensure that your pictures don't suffer from camera shake as a result of the shutter speed dropping too low. This is a very common problem when cameras are used on Automatic. If hand-holding the camera, a good standard shutter speed is 1/125 or 1/160. However, be prepared to vary your shutter speed depending on the lens you're using. The general rule of thumb is to select a shutter speed the same or higher than the focal length of the lens. As a guide:

◎ A 24mm lens requires a minimum shutter speed of 1/30.

◎ A 200mm lens requires a minimum shutter speed of 1/250.

◎ With zoom lenses the minimum shutter speed should vary as you zoom in and out. The longer the lens, or when set at the telephoto end of zoom lenses, the higher the minimum shutter speed required.

Image-stabilisation technology allows us to break this general rule to a point, but you need to understand it so that you don't drop the shutter speed below the speed at which the technology in the camera or lens can correct the movement.

Strut the Streets Charity Walk,
Sydney, Australia

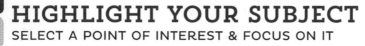

HIGHLIGHT YOUR SUBJECT
SELECT A POINT OF INTEREST & FOCUS ON IT

The very first thing to consider is the subject – what is it and why are you taking a photo of it? Successful images have a point of interest: the key element around which the composition is based and which draws and holds the viewer's attention. It's probably the thing that caught your eye in the first place.

- Always focus on the point of interest. If something else is the sharpest part of the composition, the viewer's eye will rest in the wrong place.

- Aim to place the point of interest away from the centre of the frame because centring the subject often makes for a static composition.

- Avoid including other elements that conflict with the main subject. Look at the space around and behind your subject and make sure nothing overpowers it in colour, shape or size.

Carnaval Parade, Montevideo, Uruguay

FOLLOW THE RULE OF THIRDS
... TO COMPOSE ENGAGING PHOTOGRAPHS

As you look through your viewfinder or study the LCD screen, imagine two vertical and two horizontal lines spaced evenly, creating a grid of nine rectangular boxes. Try placing the point of interest, or other important elements, on or near the points where the lines intersect.

- ◉ If you're taking a portrait, the subject is the person's face and the point of interest would be his or her eyes.

- ◉ In a landscape the point of interest may be a boat floating on a lake; place the boat on one of the intersections and also position the horizon near one of the horizontal lines.

One of the traps with the rule of thirds for autofocus cameras is that if the subject is not in the middle of the frame, it may not be in focus as the autofocus sensor is usually in the middle of the viewfinder. However, most compact and all DSLR cameras have a focus-lock facility, which you should be confident using. This facility allows you to produce more creative and technically better pictures by locking the focus on the main subject then recomposing without the camera automatically refocusing.

Night market, Hoi An, Vietnam

TIP
14

VARY THE LOOK OF YOUR IMAGES
... BY CHANGING YOUR VIEWPOINT & THE CAMERA'S ORIENTATION

The position of the camera is important for two reasons. Firstly, in conjunction with your choice of lens, it determines what elements you can include and how they are placed in relation to each other. Secondly, it determines how the subject is lit by its position in relation to the main light source.

◉ Don't assume that your eye level or the first place from where you see your subject is the best viewpoint. A few steps left or right, going down on one knee or standing on a step can make a lot of difference. Varying your viewpoint will also add variety to your overall collection.

◉ Consider whether the subject would look best photographed horizontally or vertically. Camera orientation is an easy

and effective compositional tool and is often a quick way of filling the frame and minimising wasted space around the subject. It feels much more natural to hold the camera horizontally, so it's not surprising that people forget to frame vertically. Take a different approach and start by framing vertical subjects vertically.

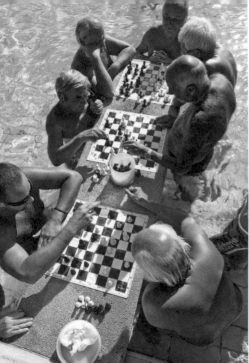
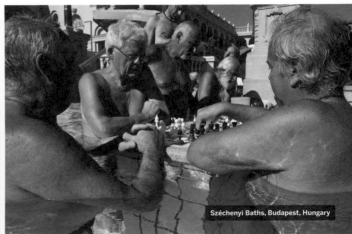

Széchenyi Baths, Budapest, Hungary

VARY THE DEPTH OF FIELD
ADJUST THE APERTURE TO FIND YOUR FOCUS

Depth of field refers to the area of a photograph, in front of and behind the point of focus, that is considered acceptably sharp. It is controlled by the aperture and is one of the most important creative controls available to the photographer. The smaller the aperture, the greater the depth of field, and vice versa:

◉ An aperture of f16 will give maximum depth of field.

◉ An aperture of f2 will give minimum depth of field.

The bottom image on the opposite page was shot with a large aperture of f2.8, consequently the only statue in focus is the statue that was focused on (third from the left). Whereas a small aperture of f16 was used for the top image, rendering all statues in focus. For general photography use f8 or f11 as your standard aperture setting. These apertures will generally allow you to use a shutter speed of around 1/125, give enough depth of field for most shots and some margin for error against inaccurate focusing.

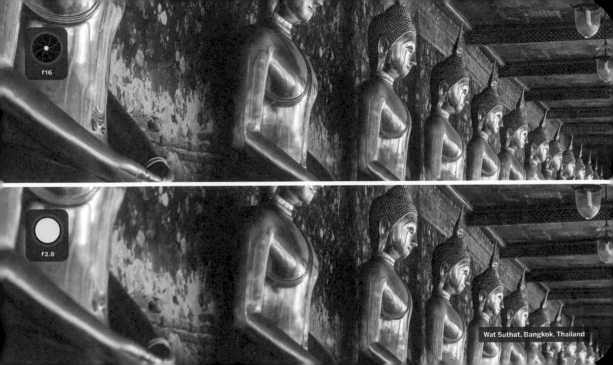

f16

f2.8

Wat Suthat, Bangkok, Thailand

REDUCE REFLECTIONS
USE A POLARISER FILTER TO ELIMINATE GLARE

Polariser filters eliminate unwanted reflections by cutting down glare from reflective surfaces, intensifying colours and increasing contrast between different elements. The level of polarisation is variable and is controlled by rotating the front of the filter and the position of the camera lens in relation to the sun.

◎ As you view your subject through the lens you can see exactly what effect the filter will have at different points in the rotation.

◎ A polariser has its most marked effect when the sun is shining and the filter is at 90 degrees off axis with the sun.

◎ It has its minimum effect when the sun is directly behind or in front of the camera.

◎ A circular polariser is the correct filter for digital cameras.

Although the effect produced by polarisers can be very seductive in the viewfinder, they shouldn't be permanently fixed on your lens. They don't enhance every photo and should be used only as a creative tool.

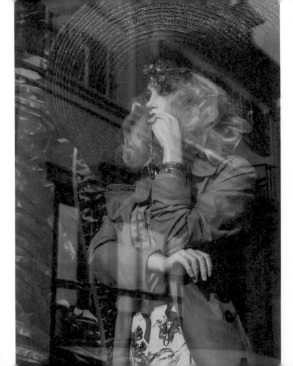
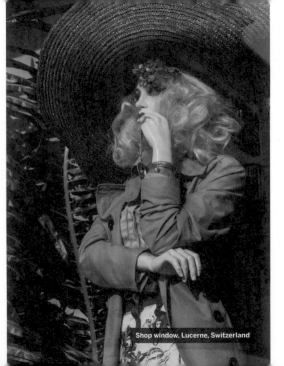

Shop window, Lucerne, Switzerland

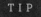

TALK TO STRANGERS

PHOTOGRAPHING STRANGERS CAN BE DAUNTING, BUT IT NEEDN'T BE; MOST PEOPLE ARE HAPPY TO BE PHOTOGRAPHED

Some photographers ask before shooting strangers, others don't. It's a personal decision, often decided on a case-by-case basis. Asking permission allows you to use the ideal lens, get close enough to fill the frame, and it provides the opportunity to take several shots, as well as to communicate with your subject if necessary. It also means you know you're not photographing someone against their wishes.

How you approach people will affect the outcome of your request for a photo. Simply smiling and holding your camera up is usually sufficient to get your intention across. You may choose to learn the phrase for asking permission in the local language,

but it can be less effective than sign language (especially when you have to repeat the sentence 10 times to make yourself understood). Approach the person with confidence and a smile. When you get the go ahead, shoot quickly, which will increase the possibility of capturing more spontaneous and natural images.

◉ A good way to get started is to photograph people who provide goods or services to you. After a rickshaw ride or buying something from a market stall ask the person if you can take their photo. Very rarely will they refuse.

Paro festival, Paro, Bhutan

USE A SHORT TELEPHOTO LENS
... FOR PERFECT PORTRAITS

The ideal focal length for capturing portraits is between 80mm and 105mm. These focal lengths give a flattering perspective to the face and allow you to fill the frame with a head-and-shoulder composition while standing at a comfortable distance from your subject.

Overcast weather is ideal for portraits. It provides even, soft light that eliminates heavy shadows and is usually flattering to the subject. It allows you to take pictures of people in all locations and use automatic metering modes to shoot quickly.

- Avoid backgrounds that are too busy or have very light or very dark patches of colour. Your eyes should not be distracted from the subject's face.

- Always focus on the eyes. It doesn't matter if other features are out of focus: if the eyes aren't sharp the image will fail.

- Expose for your subject's face: it's the most important part of the composition.

- Set your shutter speed to at least 1/125 to prevent movement causing a blurry photo.

- A wide aperture (f2–f5.6) will ensure that the background is out of focus and minimise distracting elements.

- Composing the photo vertically will generally help to minimise distracting, empty space around your subject's face.

- In low-light situations increase the sensor's ISO rating rather than use flash light.

Girl at cosplay (costume play),
Taipei, Taiwan

USE A WIDE-ANGLE LENS
... TO SHOW SOMEONE IN CONTEXT

Environmental portraits add context and allow the viewer to learn something about the person. This kind of portrait lends itself to the use of wide-angle lenses. The wider field of view offered by 24mm, 28mm or 35mm lenses allows the following:

- ◉ You can get close but still include plenty of information about where the subject is.
- ◉ Nothing comes between the camera and the subject at the vital moment – an essential technique in crowded situations such as markets and busy streets.
- ◉ Slower shutter speeds can be employed to maximise depth of field. This is important because the location is an integral part of the picture.

Look to add variety to your environmental portraits by capturing both formal shots, where your subject is looking into the camera, and informal shots, where people are busying themselves with something and interacting with others. People at work make excellent subjects for achieving this combination of shots. They're often less self-conscious in front of the camera because they're occupied with a familiar activity, and you'll be able to capture them looking into the lens and at what they're doing. Markets and workshops are great locations to capture images of people in an interesting environment.

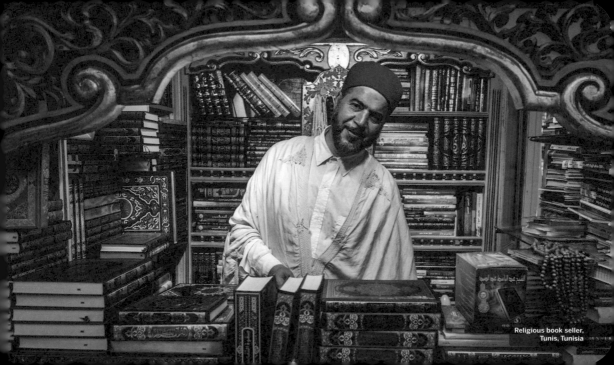
Religious book seller,
Tunis, Tunisia

SHOW LANDSCAPES SOME LOVE
CONSIDER LENS CHOICE & COMPOSITION OF PANORAMIC PICTURES

When confronted with a beautiful scene it's very tempting to put on the widest lens to try and get everything into your composition. Remember that landscapes don't have to always take in the big scene. Isolate elements that say something about the environment and complement the panoramic views. As with all good compositions, there needs to be a point of interest in the landscape, a main feature that can hold the viewer's attention. As you compose landscapes pay particular attention to the horizon, check the elements in the frame and experiment with different focal lengths:

◉ Wide-angle lenses increase the foreground and sky content, exaggerate sweeping lines and make the subjects in a landscape smaller. Make sure that the foreground and sky are interesting and relevant.

◉ Telephoto lenses allow you to select a part of a scene and to flatten the perspective, making the foreground and background elements appear closer to each other. What you focus on will become larger.

◉ Place horizons carefully. Apply the rule of thirds to ensure the horizon is straight and placed away from the middle of the frame.

◉ Scan your viewfinder or screen for unwanted elements, particularly at the edges of the frame.

◉ For maximum depth of field give the aperture priority; stop down to at least f11.

Sunset at Yavapai Point, Grand
Canyon National Park, USA

SHOOT EARLY OR LATE
LANDSCAPES LOOK THEIR BEST AT SUNRISE OR SUNSET

Professional landscape photographers habitually rise early for first light and return a couple of hours before sunset to make the most of the warm, low-angle light. This light is available to everyone. You don't need expensive equipment to get up early ... just an alarm clock and a lot of will power. To capture image files of the highest quality when the light is low:

- ◉ Select the lowest ISO setting you can (typically 100 ISO).

- ◉ Mount your camera on a tripod and use a shutter-release cable as shutter speeds are usually slow.

- ◉ For maximum depth of field and to ensure sharpness from front to back, focus on a point one-third into the scene, just beyond the foreground subject, and stop down to f16.

- ◉ Be aware that on windy days slow shutter speeds will record movement in the landscape. Swaying branches will blur at 1/15 or slower, depending on how strong the wind is. This can be very effective if desired. Clouds may also blur if exposures are longer than half a second, which may not be so effective.

- ◉ Don't accidentally photograph your shadow in the landscape. It's easy to do, especially when using wide-angle lenses. Shoot from a low angle or position your shadow in a naturally shadowed area of the composition.

Valley of the Moon,
Atacama Desert, Chile

USE A TRIPOD
... & A SLOW SHUTTER SPEED TO BLUR RUNNING WATER

The flowing water of rivers and waterfalls can be interpreted in different ways through shutter-speed selection. To give the impression of running water, experiment with shutter speeds from 1/30 to one second (opposite, left).

◉ If the flow is fast 1/30 will do and you may be able to hand-hold the camera using a wide-angle lens.

◉ For best results and maximum depth of field, use a tripod. Start at 1/30 and go down to one second depending on the rate the water is flowing and the amount of blur you're after.

◉ Quite a different effect is achieved with fast shutter speeds (1/250 and higher), which 'freeze' the water in mid-flow, bringing out texture and detail (opposite, right).

◉ A polarising filter can improve the image by cutting out reflections from the wet rock and surrounding vegetation, and will accentuate rainbows that often form in the water's mist.

Waterfalls generally photograph best in the even light of an overcast day. Contrast between the water and the surroundings is often naturally high, and the soft, indirect light allows detail to be recorded in the highlights and the shadows.

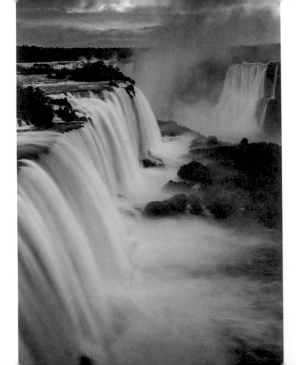
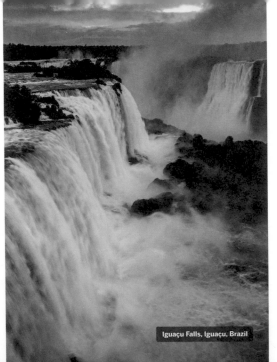

Iguaçu Falls, Iguaçu, Brazil

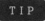

TIP 23 OVERRIDE THE LIGHT METER

WHEN SHOOTING SNOW & ICE THE LIGHT METER IS TRICKED BY THE HIGHLY REFLECTIVE SUBJECT

Snow and ice and any other expansive area that is predominantly white, such as salt pans and white sandy beaches, cause a high level of reflection when they're the dominant element of a composition, and the camera's light meter will underexpose the scene, particularly on sunny days.
To compensate:

◎ Override the meter. Older cameras may require you to overexpose by one or two stops. Modern cameras with advanced metering systems cope much better, but it's still worth overexposing by a half-stop and one stop until you learn how your camera's meter performs in different situations.

◎ Be careful using polariser filters with predominantly bright, white subject matter. Often blue skies are already very dark and can go almost black.

◎ Shooting early or late in the day is recommended as the contrast levels are more manageable and the lower angle of the sun brings out detail and texture in the snow, ice, salt or sand.

◎ In overcast conditions snow and ice will record with a bluish cast so check the white balance setting if you're shooting JPEGs.

Svinafellsjökull Glacier, Vatnajökull
National Park, Iceland

FILL THE FRAME
... WHEN SHOOTING FLOWERS

The colour and natural beauty of flowers make them a favourite photography subject, whether they're growing in pots and decorating the exterior of a building, flowing down fences, growing wild as solitary specimens or dominating the landscape in dramatic fields of colour. Flower studies require macro equipment if you want to fill the frame with a single flower and achieve maximum impact. If you're using the macro facility on a zoom lens and can't fill the frame, treat the flower as one element of the picture. In a sense you're looking to create an environmental flower portrait. Alternatively, look for groups of flowers to fill the frame with a repetitive pattern of colour and shapes.

⊙ Unless the flowers are all parallel to your camera or you're able to work with an aperture of at least f8, you'll find that typically only one or two flowers will be in focus. Select the best specimen and make it the focal point, preferably away from the centre of the frame. The other flowers will form a soft and very pleasing background.

⊙ If there is the slightest breeze, flowers move and blur, which can look great if that's what you want. Shutter speeds over 1/125 will overcome most movement except on very windy days, but if using speeds slower than 1/60, wait for a still moment.

Display at Floriade,
Canberra, Australia

MOVE AROUND
... TO CAPTURE THE SPORTING EXPERIENCE

Without press accreditation, photographing big events is usually confined to the grandstands, so if you have only one opportunity to go to a game you'll have to make the most of the general access areas and the view from the seat you're given. This will often give you plenty of variety anyway, particularly if you view the photo opportunities as going beyond the field of play. Going to the biggest game in town is a cultural as well as sporting experience, so you'll have plenty to do even if you can't get as close to the on-field action as you'd like.

- Look to capture crowd shots, spectator activity, traders selling sports paraphernalia, and the stadium itself.

- For more opportunities to shoot close-up action, go to lower-grade games where access to the fence or boundary is easier. You'll also get access to the boundary line, or even the playing arena, at cultural sporting events that are part of a festival.

- No matter what venue, to photograph the action you'll need a long telephoto lens, ideally around 300mm.

- Even on the boundary line of big fields you won't be able to successfully photograph a lot of the play, so wait until the action comes within range of your lens and shoot quickly because you'll only get a few chances during a game. Select a sensor setting that allows a minimum shutter speed of 1/500 (but ideally 1/1000) to freeze the action.

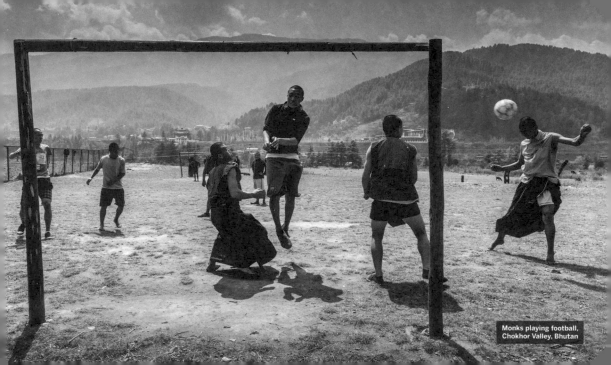

Monks playing football,
Chokhor Valley, Bhutan

LIGHT YOUR LUNCH
... FOR MOUTHWATERING FOOD PHOTOGRAPHY

Whenever you sit down to eat or drink at a street stall, cafe, bar or restaurant and place an order, a photo opportunity will soon be delivered to your table. To make the most of it:

- ◎ Look for an area of soft, even light.

- ◎ Choose a table by a window, or outdoors in open shade or under an umbrella if it's sunny. The best on-location food and drink shots are taken with natural light. A camera flash will rarely make the food look appetising so is best avoided.

- ◎ Place glasses of liquid against the light to achieve side or back lighting, which will emphasise the colour and the little bubbles of a freshly poured fizzy drink.

- ◎ Plan the shot before the food or drinks arrive. Is it to be a close-up of the plate of food or will it include cutlery and a glass of wine? Will you use the table itself as the background for the cocktails by looking down or shoot from a lower angle that will take in some background? Either way, clear the table of potentially distracting bits and pieces such as ashtrays, phones, sunglasses, guidebooks, maps etc, unless they are to be deliberately included.

Chicken satay, Bangkok, Thailand

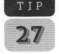

CAPTURE CITYSCAPES AT DUSK
NIGHTFALL IS THE BEST TIME TO SHOOT STUNNING CITY SCENES

Cities and buildings take on a completely different look and mood after sunset, and dusk images will add an extra dimension to your collection. The best time to photograph is around 10 to 20 minutes after sunset. By then the incandescent lighting provided by interior, spot and streetlights will be the dominant light source, but there'll still be some light and colour in the sky. This combination of illuminated buildings, a darkening sky and long exposures creates strong and colourful images.

◉ Dusk and night photography requires a tripod and shutter-release cable, as exposures are generally long.

◉ To record detail in the shadows, overexpose by one and two stops, otherwise the only thing that will come out will be the lights themselves.

◉ When it's completely dark, concentrate on filling the frame with well-lit subjects and avoid large areas of unlit space, including the sky.

The other great thing about shooting cityscapes at this time of day is that it offers guaranteed results regardless of the weather (unless there's thick fog).

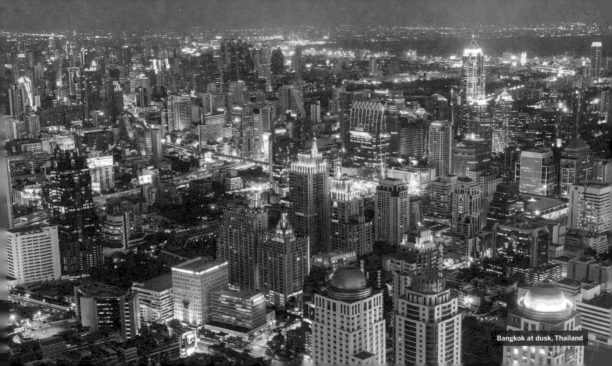
Bangkok at dusk, Thailand

GAUGE LIGHT TO SHOOT INTERIORS
SUCCESSFUL INTERIOR PHOTOGRAPHS DEPEND ON THE AMOUNT OF AVAILABLE LIGHT & RESTRICTIONS ON PHOTOGRAPHY

Photographing the interiors of galleries, museums, markets and shopping centres requires the ability to switch from one technique to another, depending on the amount of available light and the restrictions placed on photo-taking by the establishment. Individual displays are sometimes lit with spotlights intense enough to allow the camera to be hand-held. Generally, though, light levels are too low to photograph interiors hand-held without increasing the sensor's ISO rating, using flash or mounting your camera on a tripod. Be prepared for all three situations.

- In many places flash and tripods are prohibited, so there'll be no choice but to increase the ISO rating or put away your camera.

- If flash is permitted remember to keep your subject within the range of your unit.

- Even if flash is permitted turn it off to photograph displays behind glass to avoid an image-ruining highlight as the flash light bounces straight back into your lens.

- A tripod is the best solution if allowed, as it gives the most consistent results in any situation. No matter how low the light, you can use your standard sensor setting and achieve the exact amount of depth of field that you require.

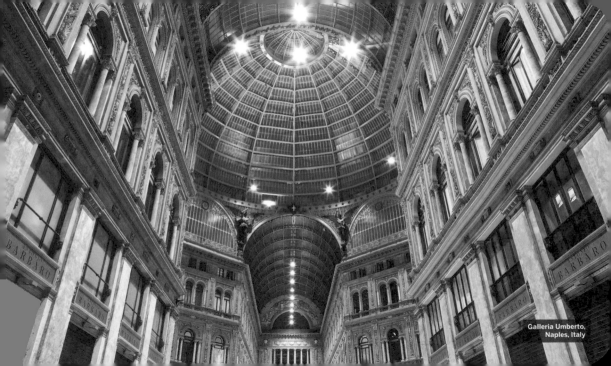

Galleria Umberto,
Naples, Italy

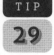

USE A FAST ISO
... TO CAPTURE THE ATMOSPHERE OF NIGHTLIFE

Live music, cultural shows, the bar scene and crowded nightclub dance floors are just some of the activities to keep us entertained, and still photographing, late into the night. Most of the subjects are found indoors and the combination of very low ambient light with bright spotlights, crowded venues and moving people make these subjects as challenging as it gets.

Even in dimly lit nightclubs and bars there is usually enough light to take pictures without flash, but you'll find yourself setting the sensor between 800 ISO and 3200 ISO. In bars, the best opportunities are around the bar itself, which is usually illuminated and often a distinctive feature of the establishment. Stages where cultural shows

and bands perform are usually brighter than the rest of the venue and getting up close to the singers, dancers and musicians will let you take advantage of the spotlights and general stage lighting, allowing good results to be achieved even with compact and phone cameras.

◉ Keep your equipment simple. A small shoulder bag with one camera and your fastest wide-angle zoom or fixed wide-angle lens and flash unit is all you'll need. It makes working in crowded spaces more comfortable for you and the other patrons.

Pawn Shop nightclub,
Miami, USA

GET TO THE PARADE EARLY
ARRIVE EARLY TO CAPTURE UNIQUE IMAGES

Parades and processions are often a feature of festivals and are particularly demanding subjects in their own right – you don't get a lot of time to think, compose and shoot. Large, organised parades attract big crowds and routes are often roped off, making it difficult to move around quickly. You may also prefer to remain in one place if you're with family or friends. If so:

- Choose your position carefully. Consider the direction of the sun and the background possibilities in relation to the direction of light. You don't want to find yourself looking into the sun or at a jumble of power lines.

- If you do have the freedom to move, try walking with the parade. This will give you the opportunity to concentrate on the elements you find most interesting and to try various viewpoints.

- For informal shots and opportunities to get close, seek out meeting places where the participants gather before and after the parade. This is a great time to take portraits of people in costume, which is difficult while the parade is moving. Be on your toes because the atmosphere is conducive for people to play up for your camera.

- Once the parade starts don't forget to pay some attention to the watching crowds. Often they're so engrossed in proceedings that you'll capture great expressions as they react to what they're witnessing.

Carnaval Parade,
Montevideo, Uruguay

VISIT FAMOUS PLACES

... MORE THAN ONCE; FAMILIARITY IS THE SECRET TO SHOOTING ICONIC SUBJECTS

One of the great challenges for the travel photographer is to capture images that in a single frame encapsulate a distinguishing feature of the country they're visiting. Every country has natural landforms, buildings and monuments on its 'must-see' list. Spend five minutes looking at postcards and you'll soon get a feel for what are considered the classic views of its most famous places. The classic view is absolutely worth taking, but the challenge is to do it as well as – or better than – it's been done before. In many places it's easy to get to the vantage points and replicate well-known pictures. That's no problem – it's a famous view because it's a great view – but it's better to treat it as a starting point for your own interpretation.

◉ Do this through your choice of viewpoint, lens and, of course, the light you shoot in.

Famous places always deserve more than one visit. On your first visit you'll be inclined to blaze away at the subject from all angles. A second visit can be approached more calmly and deliberately. A review of published material such as postcards and souvenir books after your first visit will make more sense. You'll know where things are, where the light will be and what time you need to be there. New and interesting pictures are possible; you'll just have to work harder to acquire them.

Revisiting places is one of the best ways to improve your travel photographs.

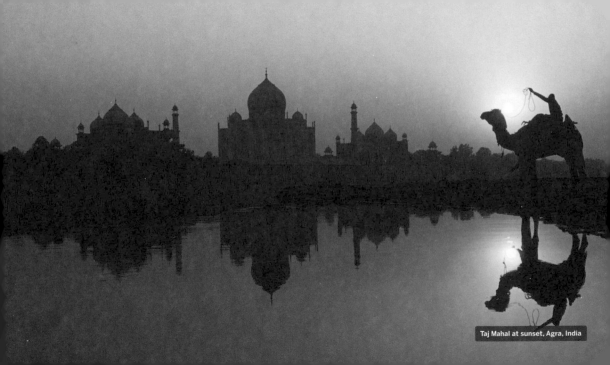
Taj Mahal at sunset, Agra, India

GRAB A WINDOW SEAT
TO TAKE PICTURES FROM THE AIR, SHOOT FROM A WINDOW SEAT WITH A FAST SHUTTER SPEED

Flying at low altitudes in a light plane, helicopter or hot-air balloon, with a clear view of the world below is a wonderful experience. Make sure you get a window seat and:

- ⊙ Set the shutter speed at 1/1000, or as high as possible, in planes and helicopters. Shutter speeds of around 1/250 are sufficient in hot-air balloons.

- ⊙ Don't rest any part of your body against the aircraft because vibrations will cause camera shake.

- ⊙ Keep the camera within the cabin; don't let it protrude through the window or open door as it will be impossible to keep still.

- ⊙ Keep horizons straight; this requires constant adjustment.

- ⊙ Start your flight with empty memory cards and have spares handy.

- ⊙ Most importantly, don't hesitate – shoot quickly and often.

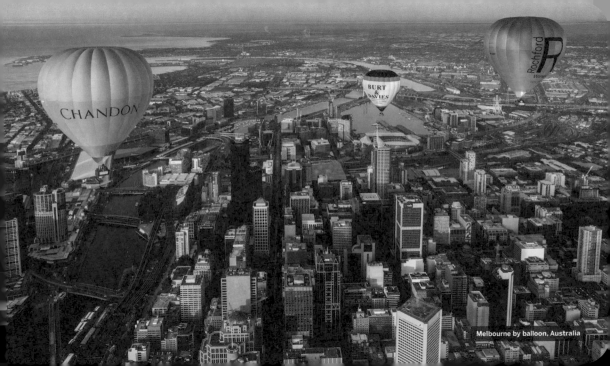

Melbourne by balloon, Australia

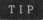

ADD A SENSE OF SCALE
INCLUDE ELEMENTS THAT ARE OF A FAMILIAR SIZE IN YOUR COMPOSITION

To emphasise the vastness of a landscape, the bulk of a landform or the height of a building, include elements that are of a familiar size in your composition. This will add a sense of scale that is clearly understood.

- Place the element in the middle distance and use a standard to telephoto lens (80–135mm) for best effect. If the subject is too close to the camera and you use a wide-angle lens, perspective will be exaggerated. The subject will appear far bigger than the background elements, and all sense of scale will be lost.

- If you're using people to show scale, ensure that they're looking into the scene. This will lead the viewer's eye to the main subject rather than to the edges of the composition.

Street artist at Berlin Wall,
Berlin, Germany

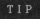

ANTICIPATE THE MOMENT
... & USE A FAST SHUTTER SPEED TO FREEZE ACTION AND CAPTURE MOVEMENT

Where the activity is fast and furious, shutter speeds faster than 1/500 will freeze the action and capture the moment with great detail.

- Fast shutter speeds will result in wider apertures and less depth of field, but get the balance that suits you and the subject best by increasing your sensor's ISO sensitivity.

- When the subject is coming towards you, you don't need as fast a shutter speed; 1/125 may do the job. Select the Predictive or Tracking autofocus mode or if your camera doesn't have that feature, prefocus on a spot on the ground and release the shutter when your subject gets there.

- 'Shoot first, think later.'

There will be times when you, the photographer, are the one moving because you're in a speeding vehicle, riding a bike or on the back of an ambling camel, elephant or horse. Success rates in these circumstances will be low, but if you must shoot:

- Set the fastest shutter speed possible (aim for 1/1000).

- Select a standard to short telephoto lens or zoom setting to around 50mm to 100mm to frame out the foreground.

- Switch to manual focus and set the focus on infinity.

- Look ahead for a clear viewing spot.

- Don't hesitate.

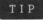

CAPTURE REFLECTIONS

PLACE THE CAMERA LENS AS CLOSE TO THE REFLECTIVE SURFACE AS POSSIBLE

TIP 35

Reflections add a dynamic and sometimes surprising element to photographs. The water in rivers and lakes are the most common source of reflective surfaces, but a keen eye will see the potential for reflections in other wet surfaces such as roads and puddles of water after rain (see opposite) as well as windows and the glass facades of high-rise buildings.

◉ The key to maximising the reflection is to place the camera lens as close to the reflective surface as possible. Consequently, you'll find yourself having to shoot from a kneeling or lying position for the best effect.

Reflections in large bodies of water can't be guaranteed, but are more likely early in the day. See what effect a polarising filter has on the reflection as you rotate it. You can sometimes get two different-looking photos by changing the position of the filter. Also, be aware that the reflected part of the image is usually darker than the subject itself. Take your meter reading from, and focus on, the actual subject rather than the reflection so that the subject is sharp and correctly exposed.

Harbour after rain,
Syracuse, Italy

MAKE SUNSETS MORE INTERESTING
SILHOUETTE SUBJECTS AGAINST COLOURED SKIES

Place an object in front of a much brighter background and expose for the background; the foreground subject will be recorded as a solid shape without detail, or silhouetted. The most commonly seen silhouettes are taken against the colourful skies of sunrise and sunset. Silhouetting an interesting or familiar shape against a bright and colourful background gives a point of interest and adds depth to what otherwise may be a mundane image.

When the sun is below the horizon, behind cloud, or isn't in the frame, meter readings are usually accurate.

◉ If the sun is in the frame, override the recommended meter settings or the image will be underexposed (leaving you with a well-exposed sun in the middle of a dark background). This effect is exaggerated with telephoto lenses.

◉ To retain colour and detail in the scene take a meter reading from an area of sky adjacent to the sun and then recompose. Modern cameras with advanced metering systems handle these situations pretty well, but it's still worth using a couple of extra frames and overexposing by half a stop and one stop to be sure.

Chinese fishing nets at sunset, Fort Cochin, India

AVOID LENS FLARE
... WHEN SHOOTING DIRECTLY INTO THE SUN

Lens flare, caused by stray light entering the lens, reduces contrast and records as patches of light on the sensor. You can usually see lens flare (if you're looking for it) in the viewfinder or on the LCD screen. With DSLRs it can be highlighted by stopping down the lens with the depth-of-field button (if your camera has one). A slight change in camera angle or viewpoint will usually solve the problem, or try moving so that the sun is directly behind an element in the scene.

You won't always get lens flare when the sun is in the frame; it depends on atmospheric conditions, the angle at which the sun strikes the lens and the quality of the lens.

⊙ Lens hoods help prevent flare but shading the lens with your hand may also be required (don't let your hand enter the field of view).

Sunset at Yellow Waters, Kakadu National Park, Australia

SHOOT WILDLIFE
... WITH A LONG-RANGE LENS

A focal-length lens of 300mm is generally considered essential for photographing animals in the wild. The magnification is strong enough to satisfactorily photograph the majority of animals and will allow frame-filling portraits of those you can get close to.

Some wildlife photography is possible with compact cameras with typical zoom lenses, such as 38–90mm, or DSLRs with standard zooms, such as 28–105mm. In many national parks, particularly around camp grounds, some animals are quite used to human presence and will allow you to get close enough. In the wild the limitations of such equipment can make for a frustrating experience, except in one or two special places such as the Galápagos and Antarctica. The eye will zoom in on distant animals and exaggerate their size, but they will be insignificant on the sensor.

◉ To avoid disappointment concentrate your efforts on animals that you can get close to and on compositions that show the animal in its habitat.

Even if you're travelling independently, joining a tour to see the local wildlife is an option worth considering, and often it's mandatory. You'll benefit from having a knowledgable guide or naturalist who will point out the animals and direct the vehicle, boat or elephant to areas of recent sightings.

Salt water crocodile, Kakadu National Park, Australia

TIP 39
SET YOUR ALARM CLOCK
EARLY MORNING & LATE AFTERNOON IS THE BEST TIME TO CAPTURE ANIMALS BEHAVING NATURALLY

Many animals are at their most active early in the morning and late in the day. Consequently, you'll often be shooting in low light and will require high ISO settings – this will ensure you are working with appropriate shutter speeds to prevent both camera shake and blurring if the animal moves. Adjust your sensor's ISO setting with the changing conditions, decreasing the speed as the day brightens up.

Seeing animals in the wild is pretty special, but it's no excuse for forgetting everything you've learned about good photography.

- The first challenge is to get close enough.

- It's also important to select a viewpoint that considers the direction of the light and the background, just as with any subject, although this may not always be possible without missing the moment. Shoot first, and if you've got time improve your position for a second attempt.

- Always focus on the eyes; everything else can be out of focus but if the eyes are not sharp the photograph will fail.

- If you don't have long lenses look for situations that show the animals in their habitat. These pictures will be particularly pleasing when the animal hasn't been alerted to your presence.

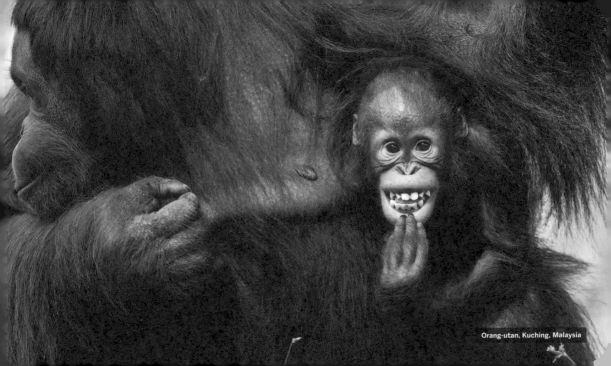

Orang-utan, Kuching, Malaysia

BE PATIENT
... WHEN CAPTURING BIRDS IN FLIGHT

It's one thing to photograph a bird resting on a branch, quite another to capture it in flight. But flying is what birds do best, it's what distinguishes them from ground-dwelling species and so capturing birds in flight is fundamental to bird photography.

- A 300mm lens is adequate for larger birds, but, except for some rare exceptions, to have any hope of filling the frame you really need a focal length of 500mm or even 600mm.

- Take up a position and follow your chosen bird as it flies in your vicinity, and wait for it to come into the range of your chosen focal length.

- Use your camera's Servo or Predictive focus mode to keep the subject sharp. You have the choice of selecting a fast shutter speed (1/500 or higher) to stop the movement for a crisp image, or use slower shutter speeds, such as 1/30 or 1/60, to blur the background and the motion of the bird's wings.

- To emphasise the shape of the bird and the colour of its feathers pay careful attention to the background so that it doesn't get lost in a jumble of branches, twigs and foliage. The sky makes a perfect backdrop, as does the sea – both offer large areas of solid colour (without distracting elements) against which the bird will stand out.

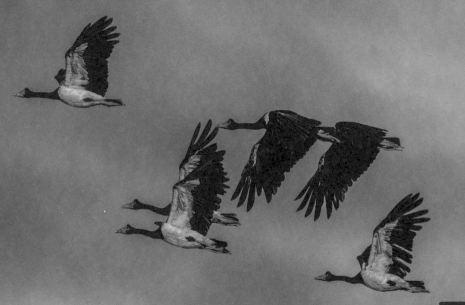

Magpie geese,
Bamurru Plains, Australia

RECORD LIGHT TRAILS

TRACING THE PATTERNS LEFT BY MOVING LIGHT ADDS DRAMA & COLOUR TO PHOTOGRAPHS

Light trails, combined with other incandescent lights and colour in the sky at dawn or dusk, add a dynamic element and can make for quite powerful images. Favourite subjects include fireworks and the lights of moving cars. With all light-trail subjects mount your camera on a tripod, use a shutter-release accessory and turn off the flash.

◎ There's no need to increase your sensor's ISO rating; use your preferred settings and capture maximum detail and sharpness.

◎ For car lights set the aperture to around f11 to f16 for lots of depth of field and let the camera select the shutter speed, which could be anything from 2 to 15 seconds depending on the amount of ambient light.

The look of the images will vary from frame to frame depending on the intensity of the lights and length of the trails, as determined by the speed and number of the vehicles. The image opposite was captured with a shutter speed of 4 seconds at f11.

◎ The same technique is used for shooting fireworks, although set the shutter speed to 20 or 30 seconds as the most interesting and colourful pictures are created by recording several bursts of light on the one frame. If there are lengthy delays between bursts use the B setting, which leaves the shutter open for as long as you wish.

Sukhumvit Road,
Bangkok, Thailand

DON'T PUT YOUR CAMERA AWAY

... WHEN IT RAINS; GET OUT THERE, GET WET & YOU MAY BE REWARDED WITH FANTASTIC PHOTOGRAPHIC OPPORTUNITIES

Just because it's raining, or threatening to rain, doesn't mean you have to put your camera away. Unsettled or unusual weather often brings with it moments of spectacular light and a change in the daily activity of the locals. Street vendors have to cover up or pack up, umbrellas appear from nowhere, busy streets can become deserted and tourists are suddenly scarce at major sights. Wet streets also bring about the possibility of reflections adding an unpredictable dynamic element to familiar scenes.

Most cameras can take a fair bit of light rain; just wipe them dry as soon as you get inside. Unless someone is on hand to hold an umbrella for you, shooting with one hand from under an umbrella

isn't easy – especially as the light is probably low. It's much easier to keep your camera under your jacket between shots. The camera-in-the-plastic-bag technique (see p116) works well if the downpour isn't too heavy.

It's also important to stick to your plan when the weather appears against you. The disappointment of waking to a cloudy predawn sky can quickly turn to elation if you have the strength to stick to your plan (instead of going back to bed) and head to your predetermined viewpoint regardless. You can't judge the weather from 10km away, and you can't assume there won't be great light for just a couple of minutes.

Shwedagon Pagoda,
Yangon, Myanmar

PROTECT YOUR CAMERA

A PLASTIC BAG & RUBBER BAND WILL SHIELD YOUR CAMERA FROM THE ELEMENTS

Weather conditions and circumstances can change rapidly. Just because it's a perfectly still, sunny day when you leave your hotel doesn't mean that a dust storm won't engulf you an hour later. A walk along the beach will put you in contact with salt water, sea spray and sand which can cause irreparable damage to camera equipment, and shooting certain festivals can leave you and your gear covered in water (Songkran in Thailand), coloured powder (Holi in India) or tomatoes (Spain's Tomatina Festival), so it's best to be prepared for all eventualities.

You can buy camera and lens covers that will be useful if shooting in rain, snow or around sand and sea is a regular activity for you. Some camera bags have an outer shell built-in for protection against the elements. But if you don't have a weather-proof camera one quick and easy solution is the 'plastic bag and rubber band' trick:

- ◎ Cut a hole in the bottom of a plastic bag just big enough for the lens to fit through.

- ◎ Use a rubber band to secure it in place on or just behind the lens hood.

- ◎ Access the viewfinder and shutter release through the bag's original opening.

- ◎ The lens hood will help protect the UV filter on the front of the lens, but keep checking it and wiping it clean as necessary.

Songkran Festival,
Bangkok, Thailand

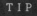

BACK UP YOUR IMAGES

THE NEED TO BACK UP YOUR IMAGES CANNOT BE EMPHASISED ENOUGH!

This tip could just as easily have been on the first page. Storing the only version of your digital images on the memory card in your camera while you're travelling, or on a computer hard drive at home, is asking for trouble. Cameras are prime targets for theft and hard drives eventually die.

Ideally you should always have two copies of your images on separate storage devices in seperate locations. On the road your choices include backing up to a laptop computer, tablet or portable storage device. Alternatively, if you wish to avoid carrying these items, use local CD/DVD transfer services. At home or on the road, wherever internet connection is possible you can upload your images to online backup and storage facilities, which provide an easy way to add a high level of security to protecting your precious collection, and other important data as well. There are plenty of options including Dropbox, SugarSync, Mozy, Apple iCloud and photo-dedicated sites such as PhotoShelter, Zenfolio, Flickr and Mosaic. These systems offer solutions for everyone, from those who want to save the family photo collection, to professional photographers. The services compete on price, storage amounts, features and sharing options, so check out a few, find one that suits you and start backing up those photos before it's too late. All you need is a computer, a broadband connection and, most importantly, the discipline to do it.

Amusement stand on beach, Mamallapuram, India

WORK WITH YOUR IMAGES

TIP 45

GET TO GRIPS WITH DIGITAL ASSET MANAGEMENT (DAM)
& DO IT SOONER RATHER THAN LATER

--

You must have an easy, efficient and fast way of moving your image files from your camera to your computer, reviewing and assessing them, editing, storing and keeping track of them. Most important is a system that allows you to find the images you want quickly and easily and to know where, what and who they are of. It might be clear now, but five years and several thousand images later and you may not be so sure. A consistent metadata and key wording regime is the best thing you can do for your image collection. Metadata is information about the image that is attached to the image file and typically includes your name, location data such as country, state and city, a brief descriptive caption and relevant key words.

Computer users will be familiar with managing text and image files via a folder system using the file manager in a computer's operating system (OS). Image-workflow software takes the place of the computer's OS file manager, and images are imported into its library system instead. It's then possible to browse, compare, sort, add metadata, process raw files, edit and export files to share or print. Most importantly you can search your entire image collection at once, not just one folder at a time. Dedicated workflow software includes Apple's Aperture and iPhoto (which is bundled with all Macs) and the cross-platform Adobe Lightroom, Corel AfterShot Pro, CyberLink PhotoDirector and ACDSee Pro applications.

Federation Square,
Melbourne, Australia

GLOSSARY

APERTURE
Opening in the lens that allows light into the camera body: variable in size and expressed in f-numbers

BOUNCE FLASH
Technique of reflecting the flash-unit light from a ceiling, wall or other reflective surfaces to diffuse and soften the light

CENTRE-WEIGHTED METERING
Reads the light reflected from the entire scene and provides an average exposure reading biased towards the centre section of the viewfinder

COMPRESSION
Process for reducing digital image file size by discarding some of the data

CONTRAST
The difference between the lightest and darkest parts of a scene

DEPTH OF FIELD
The area of a photograph, in front of and behind the point of focus, that is considered acceptably sharp

DYNAMIC RANGE
The ratio between the brightest part of a scene (the highlights) and the darkest part of the scene (the shadows) in which an image sensor can record detail

EXIF (Exchangeable Image Format)
File format that embeds image-capture information within a file

EXPOSURE
The amount of light allowed to reach the camera sensor or film

EXPOSURE MODES
Controls for exposing the sensor or film by prioritising one setting (shutter speed or aperture) over the other – can be manual, semiautomatic and fully automatic modes

FIELD OF VIEW
Image area that the lens provides

FILE FORMAT
Manner in which the data captured by a camera to create a digital image is stored so that it can be retrieved and processed using photo-editing software

FILL FLASH
Technique used to add light to shadow areas containing important detail

FILTER
Optical accessory attached to the front of the lens, altering the light reaching the film; used for a range of technical and creative applications

FLARE
Stray light that degrades picture quality by reducing contrast; records as patches of light

FOCAL LENGTH
Distance from the centre of the lens when it is focused at infinity to the focal plane

FOCUS POINT
Point on the focus screen that determines what the lens focuses on

F-STOP
Measurements that indicate the size of the lens aperture

HISTOGRAM
Graphic representation of the distribution of pixels in a digital image

HOT SHOE
Place on camera body for mounting an accessory flash unit

INTERPOLATION
Creation of new pixels to fill in data gaps between existing pixels, typically used when images are enlarged

ISO
International Organization for Standardization, which sets the standards for film-speed rating

ISO EQUIVALENT
The sensitivity of digital camera sensors to light, based on the sensitivity of film to light

LIGHT METER
Device for measuring light

GLOSSARY

LOSSLESS COMPRESSION
Compression process that results in smaller digital file size without compromising image quality

MACRO LENS
Lens designed to give a life-size image of a subject

MEGABYTE (MB)
1024 kilobytes (KB) of digital data

MEGAPIXEL (MP)
One million pixels

MEMORY CARD
Removable and reusable storage medium used by digital cameras

METADATA
Information about an image, attached to the digital file

NOISE
Error or stuck pixels in a digital image file generated during the conversion of data to pixels (colour noise); electronic grain that appears as a speckled pattern

OPTICAL ZOOM
Lens with variable focal lengths; zoom effect is achieved by physically moving the lens in and out of the camera body

PIXEL
Abbreviation for picture (pix) element (el); the smallest amounts of information that combine to form a digital image

PIXEL COUNT
Total number of pixels on a sensor; calculated by multiplying the number of pixels on the vertical and horizontal axes

PRIME LENS
Lens with fixed focal length

RANGEFINDER
Focusing system that measures the distance from camera to subject by viewing it from two positions

RAW
File format where images are compressed using a lossless process, thereby retaining all data originally captured

RESOLUTION
Degree to which digitally captured information displays detail, sharpness and colour accuracy

SATURATION
Measure of the intensity of colour in an image

SENSOR
Semiconductor chip made up of photodiodes that convert light into numerical data so it can be processed, stored and retrieved using computer software

SHORT LENS
Wide-angle lens

SHUTTER
Mechanism built into the lens or camera that controls the time that light is allowed to reach the sensor or film

SHUTTER SPEED
The amount of time that the camera's shutter remains open to allow light onto the sensor or film

SPOT-METERING
Light meter reading from a very small area of the total scene

STANDARD LENS
Lens with a focal length of 50mm or 55mm, and an angle of view close to what the eye sees

TELEPHOTO LENS
Lens with a focal length longer than a standard 50mm lens

TIFF (Tagged Image File Format)
Industry-standard file format commonly used for storing images intended for print publishing

WHITE BALANCE
Digital camera function that adjusts colour to ensure that white is recorded as white under all light conditions

WIDE-ANGLE LENS
Lens with a focal length shorter than a standard 50mm lens

INDEX

ACKNOWLEDGEMENTS

ABOUT THE AUTHOR Over the past 30 years, Richard I'Anson, a double Master of Photography, has travelled the world and amassed a compelling collection of images, featured in more than 500 editions of Lonely Planet titles. To see more of his work visit www.richardianson.com.

PUBLISHING DIRECTOR Piers Pickard
PUBLISHER Ben Handicott
PROJECT MANAGER Robin Barton
ART DIRECTION Mark Adams
DESIGN Leon Mackie
PRE-PRESS PRODUCTION Ryan Evans
PRINT PRODUCTION Larissa Frost

November 2013

ISBN 978 1 74321 847 1
Published by Lonely Planet Publications Pty Ltd
ABN 36 005 607 983
© Lonely Planet 2013
Printed in China
10 9 8 7 6 5 4 3 2

LONELY PLANET OFFICES

Australia Locked Bag 1, Footscray, Victoria, 3011
Phone 03 8379 8000 Email talk2us@lonelyplanet.com.au
USA 150 Linden St, Oakland, CA 94607
Phone 510 250 6400 Toll free 800 275 8555
Email info@lonelyplanet.com
UK Media Centre, 201 Wood Lane, London W12 7TQ
Phone 020 8433 1333 Email go@lonelyplanet.co.uk

www.lonelyplanet.com